Fruit of the Orchard

Fruit of the Orchard
Environmental Justice in East Texas

Photographs by
Tammy Cromer-Campbell

Essays by
Phyllis Glazer
Roy Flukinger
Eugene Hargrove
Marvin Legator

UNIVERSITY OF NORTH TEXAS PRESS |Denton, Texas

Design by Robert Tombs
Printed in China

10 9 8 7 6 5 4 3 2 1

Permissions:
University of North Texas Press
PO Box 311336
Denton, TX 76203-1336

The paper used in this book meets the minimum requirements
of the American National Standard for Permanence of Paper for
Printed Library Materials, z39.48.1984. Binding materials have
been chosen for durability.

LIBRARY OF CONGRESS CATALOGING-IN-PUBLICATION DATA

Cromer-Campbell, Tammy, 1960–
 Fruit of the orchard : environmental justice in East Texas /
photographs by Tammy Cromer-Campbell ; essays by Phyllis
Glazer ... [et al.].
 p. cm.
Includes bibliographical references.
ISBN-13: 978-1-57441-215-4 (cloth : alk. paper)
ISBN-10: 1-57441-215-9 (cloth : alk. paper)
1. Hazardous waste sites–Texas, East–Pictorial works.
2. Environmental toxicology–Texas, East. I. Glazer, Phyllis,
1948– II. Title.
TD1042.T4C76 2006 363.72'8709764225–dc22 2006011157

Fruit of the Orchard addresses the sociological consequences of economic change, and examines the long-term effects of modern technology on the human condition. My involvement with the Winona Community has already heightened my sense of my own responsibility as a photographer to go beyond mere documentation and presentation, in order to embrace the more fundamental ethic of using my talents and skills to convey messages that need to be heard.

This book is dedicated to Douglas Hoyne, Amanda Clark, Charlie Adams, and Tommy Lee Bland Jr.

Contents

Acknowledgments ix

Introduction 1
PHYLLIS GLAZER

A Tear in the Lens 7
ROY FLUKINGER

Fruit of the Orchard 11
TAMMY CROMER-CAMPBELL

Plates 19

Preventing Future Winonas 123
EUGENE HARGROVE, PH.D

Toxicological Myths 127
DR. MARVIN LEGATOR

Acknowledgments

Tammy Cromer-Campbell

My heartfelt gratitude goes to all the people who helped make this book possible through their encouragement, time, and support. My most sincere thank-you goes to Phyllis Glazer for asking me to photograph Jeremy. That photography session propelled me into the world of environmental activism and planted the seed for this book. To MOTHERS ORGANIZED TO STOP ENVIRONMENTAL SINS (MOSES) and the community of Winona, thank you for allowing me into your lives to photograph and tell your stories. To my husband Scott C. Campbell for being there and especially for modifying my Holga cameras. To my family Diana Hidalgo, Joshua J. Cromer, Bobby and Violet Cromer, George H. Campbell, Sr., and George H. Campbell, Jr., for being supportive and encouraging. Thank you O. Rufus Lovett for being an example. Thank you to Roy Flukinger and to Dr. Eugene Hargrove for your wonderful essays. I also must mention Earlie Hudnall, Phyllis Glazer and Dr. Marvin Legator, Mary Sahs, Ross Richard Crow, Cindy Crutcher, Bari Quinn Caton, John Delicath, and Hank O'Neal. Crystal Gable—this project happened because you pointed Phyllis Glazer in my direction. And many other people who are not mentioned who made this possible.

I would like to especially thank the Blue Earth Alliance (BEA) for supporting my project, especially the founders, Phil Borges and Natalie Fobes, and all the other Board Members including Julee Geier, Marita Holdaway, and everyone else at BEA. Blue Earth Alliance is a non-profit 501(c)3 corporation dedicated to supporting photographic projects that educate the public about threatened cultures, endangered environments, and other social concerns.

Thank you to Dr. Eugene Hargrove for believing in the project from just a phone call and offering the support of the Center for Environmental Philosophy with the expertise of Jan Dickson.

A huge thank-you to the University of North Texas Press and editors Tricia Dameron and Karen DeVinney for also believing in the project. Robert Tombs, thank you for the wonderful design for this book.

The exhibit for this book is funded in part by the Blue Earth Alliance and is supported by the Center for Environmental Philosophy, Texas Southern University, and the Marshall Thurgood School of Law, the Center for Environmental Communication Studies at the University of Cincinnati, and the Vermont Environmental Law School.

Lastly, I would like to thank God.

A Texas-sized thank-you to all the fabulous people and institutions who contributed monetarily, and by purchasing the pre-publication limited edition prints and book set, made the production of this book possible.

Tammy Cromer-Campbell

Eugene Hargrove, Ph.D., The Center for Environmental Philosophy

The Blue Earth Alliance

Karen Hadden, SEED Coalition

D. Clarke Evans, President, Texas Photographic Society

Laura Pickett Calfee

Rufus and Frances Lovett

Bryan and Karen Boyd

Holly Forbes, Forbes and Butler

Dan and Jill Burkholder

Marita Holdaway

Bill Wright

Michael Kenna

Nancy and Robert Kolvik-Campbell

Hank O'Neal

Takako Taniwaki, Washington, DC

Dr. Kikuo Inaba and Mrs. Hideko Inaba, Kyoto, Japan

Sue Barham

Richard LeTourneau

Gregg County Commissioner, R. Darryl Primo

Shirrel Rhoades

John Robinson

Darren and Suzy Groce

Ellen Black, Dallas, TX

David S. Rosen

St. Clair Newbern III, Ft. Worth, Texas

Longview Museum of Fine Arts, Longview, Texas

Museum of Fine Arts, Houston

And all those who wish to remain anonymous.

Introduction

Phyllis Glazer

In 1962, Rachel Carson vividly portrayed a hypothetical town in which "some evil spell had settled on the community."[1] Carson feared this town could one day become a reality, unless strong legislation dealt expeditiously with the runaway use of toxic chemicals by industry. Nearly four decades later, her hypothetical town emerged in rural East Texas—in a town called Winona.

The story may be traced to the arrival in the early 1980s of a new industry that moved to town, not far from the school. People were told that the company planned to inject salt water from oil fields into *open-ended* wells, and fruit orchards were to be planted on the rest of the acreage. Instead, trucks from all over the United States and Mexico came to Winona to dump their deadly, *untreated* contents into the deep wells, which passed through one of the largest drinking water aquifers on the North American continent. It was then left to migrate under the lands, farms, ranches, schools, and homes in the area. The facility processed nearly every chemical known to man. No fruit orchards were ever planted.

Before long, the people of Winona began to see, smell, and taste the hazardous chemicals in their homes, on their farms, and in the school. Before long, the soil, air, and water were contaminated. Before long, the facility had violated hundreds of environmental requirements. Before long, the people were sick.

On April 30, 1988, the third anniversary of my father's death, my mother, my husband, and I made my father's lifelong dream a reality when we purchased our beautiful ranch in the "pineywoods" of East Texas.

For the first few years, my family and I enjoyed going to our ranch on weekends, holidays, and vacations. By the summer of 1990, my husband had grown to dread the drive back to Dallas, with my youngest son and me looking like doom and gloom. He finally decided that Max and I could live at the ranch, and he would come in for long weekends.

However, we soon discovered that our peaceful little spot on earth was not one at all. On October 18, 1991, on our way to his school, my youngest son and I passed through a toxic

Phyllis Glazer is President and Founder of Mothers Organized to Stop Environmental Sins (MOSES)
www.mosesnonprofit.com

cloud of chemical smoke emitted from an explosion or "upset" from a facility we only knew by its noxious smells. We had no idea that it was a toxic waste dump.

Within days, my throat and mouth felt irritated to the point that I took out my make-up mirror and opened my mouth to take a good look inside. What I saw astonished me. It looked like the roof of my mouth had melted with skin hanging down like stalactites from the ceiling of a cave. I was to find out later that these were ulcers down my throat, nose, and mouth. I also had a hole in my nasal septum.

I soon discovered that the Winona community had experienced similar adverse health effects for years. I responded to pleas for help and involved myself in an effort to protect children, families, homes, and farms.

I sought advice from the father of Karen Silkwood. Silkwood, a labor union activist who had died in a single-car crash in 1974 with speculation of foul play, had tried to keep the union work that she was involved with undercover. Her father's advice was to make sure that nobody knew about what I was doing or that everybody, especially the press, knew about it.

And so, in 1992, I used my inheritance (which my loving mother let me use while she still lives) to organize the community to form Mothers Organized to Stop Environmental Sins (MOSES), a grassroots nonprofit organization using education, litigation, and service to preserve and protect rural, low income, and minority communities from exposure to toxic substances and contamination by hazardous wastes.

Believing that the lives of our children were at stake, MOSES organized pickets, attended public hearings, called on legislators and state and federal regulators, contacted the press, went by bus twice to Washington, DC, and was even invited to the White House in 1996. These efforts were made to force the government regulators to do their job and protect our children.

The facility in Winona is a case study of what happens when the process breaks down, the rules and regulations fail to bring a company into full compliance with environmental laws, and the government fails to protect public health and safety. Communities like Winona have become governmental *oubliettes*, places the government has and wants forgotten.

Wanda Erwin's family had left Georgia after the abolition of slavery and bought almost three hundred acres in the Winona area. Wanda's land and home were right next door to the facility. She joined MOSES and we became good friends. Our relationship, though close and loving, was never one of equal footing. Wanda looked to me for empowerment and protection, and I saw in Wanda a possible reason for my being in the right place at the wrong time, with a small fortune and a stubborn determination to protect others who

couldn't defend themselves. We came to believe that there was a higher purpose to what we were fighting for. We came to appreciate and respect each other's friendship and will to fight a hopeless battle. We became loving and lifelong friends.

Wanda told me about her family's health problems. She said that two of her sons were experiencing seizures, her youngest had stunted growth and spontaneous nose bleeds, and the family's hair wouldn't grow, Wanda had permanent liver and brain damage, and they all experienced headaches, body aches, and vomiting. Wanda told me that their livestock had reproduction problems and their crops didn't grow as they had in the past. I knew that I had to get Wanda clean water. I knew in my heart that my wonderful friend's family was being slowly poisoned.

In November of 1994, MOSES was planning a major event. We were planning to picket the Texas attorney general, because he was planning to settle his lawsuit against Gibraltar without doing anything to protect the community. I wanted to get a photographer to take a photo of Wanda's youngest child, Jeremy, as a poster child for the event we would call More Time for Jeremy. My secretary told me that she knew of a photographer who she believed would do it for us—Tammy Cromer-Campbell.

I called Tammy and she readily agreed to donate her services. She had seen me on TV and read about MOSES in the newspaper, and said that she was happy to help. She called Wanda and made an appointment to take Jeremy's picture.

She told me later that she was about to ask him to look sad for the photo, but didn't have to. She took several poses of him, and we decided together on the one we would use for the poster. It was beautiful! Jeremy's little soul reached out to you from that photo, his eyes speaking of anguish and despair. Tammy had finally put a face to Winona's suffering children.

The poster event caused nothing short of a sensation, with results that no one could have expected. A month later the company agreed to settle its lawsuit with Wanda's family, and then its suit with the attorney general. The company then sold the facility. The new owner would continue operations, and MOSES would continue the fight.

About a year later, I received a call from Tammy. She wanted to take pictures of some of the other children who it was believed had been adversely affected. I gave her the phone number of Linda Smiley.

After her photo session with the Smileys, Tammy came over to my house. She was shattered! Tammy told me that she had gotten lost on her way back home, ending up in a grassy field. "It was déjà vu!" Tammy told me. She had dreamed a few years before of that same grassy field where she was protesting with me. She told me, "Phyllis, I know now that

3

I am supposed to help." Her work documenting the story of Winona through its children soon became an exhibit entitled, *Environmental Effects—Fruit of the Orchard*.

Early in 1995, the owners of the facility threatened to sue my family if MOSES continued its opposition. We decided we would not back off and go away, nor would we apologize for our First Amendment rights.

In October 1996, the company sued me, MOSES, my elderly mother, my husband, and my husband's family business of three generations of extended family. The company sued us under the civil RICO (Racketeering Influenced Criminal Organization) statute that the federal government uses to go after the Mafia.

The suit accused us of "creating a climate of fear and apprehension" and claimed that we had exposed the company to public hatred, contempt, ridicule, and financial injury and had impeached their honesty, integrity, and reputation. I believed these allegations were akin to "the pot calling the kettle black!"

We believe that *"The first and great commandment is: Don't let them scare you."*(Elmer Davis)

After two grueling years of preparing for court, the company wanted out of the lawsuit. They couldn't just dismiss the lawsuit and walk out, however, because MOSES had counter-sued them for filing a frivolous lawsuit. It took the urging of many people, including Ralph Nader, to convince me that going to trial was not the thing to do, that I had bigger fish to fry, and bigger and better things to do with my life. Sometimes the most difficult thing you must do is let those who victimized all you hold near and dear, go without justice.

On Thursday, March 20, 1997, the facility announced that it was closing its doors and discontinuing operations because the company had lost too much money. According to a press release, "The resulting closure of a chemical waste processing facility at Winona, Texas, required a fourth-quarter writedown of $7.4 million."

MOSES continues to be the public "watchdog" over the closure activities until the property has been cleaned up as much as possible.

The Winona community has paid dearly for our belief in human rights, citizens' rights over corporate interests, and the rights of poor and minority individuals/communities to equal protection and quality of life under the law. I paid dearly with great sacrifice on the part of my family and myself. Unfortunately, ordinary citizens find themselves placed on the front lines when government agencies fail to protect the public from big corporate interests. Far too many of *our* representatives simply cannot ignore big money which tends to blind their eyes while lining their purses, keeping them in office year after sell-out year, and caus-

ing public exposure to hazardous substances in the environment that directly and/or indirectly affect all living things on earth.

Tammy Cromer-Campbell has continued to take photographs of Winona's children. Before I became ill with a brain tumor, I traveled extensively to the Environmental Protection Agency and other governmental conferences across this country telling Winona's story. I always ended by holding up a poster-sized photograph that Tammy took of Jamesia, a young African-American child born and raised in Winona within 1.7 miles of the toxic waste dump. Jamesia was born with albinism, respiratory problems, and is now going blind. The photograph of Jamesia holding one of the "Wasted Babies,"® the dolls we mothers of MOSES make so that no one will forget our children, always caused a hush to fall over a room. That is the power of a toy camera in Tammy's artful hands.

1. Rachel Carson, *Silent Spring* (Boston: Houghton Mifflin, 1962), 2.

A Tear in the Lens

Roy Flukinger

> *Sometimes the well dent is visible, where once a spring oozed; now dry and tearless grass; or it was covered deep, not to be discovered till some late day, with a flat stone under the sod, when the last of the race departed. What a sorrowful act must that be, the covering up of wells! coincident with the opening of wells of tears. These cellar dents, like deserted fox burrows, old holes, are all that is left where once were the stir and bristle of human life ...*

> HENRY DAVID THOREAU, *Walden*

The great educator Robert Coles was once showing the work of a number of Farm Security Administration photographers—those lean and rich documents of America in the 1930s—to some young students. One student in particular, Lawrence Jefferson, was drawn to the work of Marion Post Wolcott—one of the less well-known but perhaps the most ethically committed of all these federal photographers. Coles was curious to know why and Jefferson had a succinct but telling response: "She's more upset with what's wrong than anyone else."

I think of that blunt but truthful response whenever I look again at the years of work that Tammy Cromer-Campbell has produced on her countless journeys to Winona. Not for her the cool objective documents found in the government files and picture press of '30s and '40s America. The photographer is not invisible in this small Texas community. Tammy has approached her subjects with great respect and proper discipline, but there is no neutral morality in the images she has created. Her ethical passion is mixed evenly with her intrinsic compassion for her subjects. But she is upset with what is wrong—and rightly so.

I need speak no further about the industrial blight that has laid waste to the "orchard" of Winona's family and children. Tammy tells that story elsewhere in this volume—aided by other important voices from the sciences and the community itself. And she gives a critical place on the dais also to Phyllis Glazer, that irresistible force of nature and conscience who has given that rarest of human gifts—hope—to people who previously had none. It is her

Roy Flukinger is Senior Curator of Photography
Harry Ransom Humanities Research Center
The University of Texas at Austin

7

story and theirs—elevated by the steel and majesty of Tammy's photographs—which tell this tale with such terrifying clarity.

That Tammy's imagery is powerful is not at issue here. Ever since she began showing us her first results from the mid-1990s, it was obvious that something profound had stirred her heart and ignited her vision. The photographs of the Winona families never failed to shake us up, and as she continued to document their faces and tell us the stories of their lives—and, unfortunately, in many instances their deaths—it was evident that she was continuing on in the tradition of concerned documentary photographers everywhere.

The arc of that tradition is told in full in many fine photohistorical volumes. Just know that ever since the growth of the industrial age of the early nineteenth century, a social awareness for those adversely affected by this era has consistently grown throughout America, Britain, and Europe. Stories and essays on this topic were further enhanced with the judicious publication of images—at first with engravings but after the 1840s, with photographically based imagery as well. Social documentation became an important discipline in and of itself. It has been practiced by photographers throughout a century and a half and among its dedicated and foremost practitioners will be found such important figures as John Thomson, Jacob Riis, Lewis Hine, Paul Martin, Bill Brandt, Walker Evans, W. Eugene Smith, Russell Lee, David Douglas Duncan, Don McCullin, Eugene Richards, and Stephen Shames.

Beyond just "telling a story," many of them brought a firm artistry to bear, using the visual elements at their command to discover the strength of their subjects and to bring design and contrast to impact and persuade the viewer. In the process of seeing and recording, many of them also developed a voice that helped their photographs to speak out as well. As Fritz Henle, another pioneering twentieth-century freelancer, once explained: "How could you meet and talk with these people, see how they lived, and not be moved? Of course we wanted our cameras to also be able to do good for others. The eye can weep; why can't the camera lens?"

In addition, it is important to note that Tammy knows the process and technique of photography as well. She has practiced her art for decades and, if you have had the chance to watch her teach or to examine her portfolios from earlier projects, you know that her artistry is backed up with solid experience, darkroom expertise, and a very fine print quality.

I mention this because, from the project's start with her portrait of Jeremy Erwin in 1994, Tammy made the conscious decision to put aside her traditional studio and portrait

Roy Flukinger

cameras and chose to do the work with her Holga cameras. It was, for many, a somewhat controversial choice.

The Holga is a cheaply made, 120-roll-film, plastic camera manufactured in China. Emphasis on the cheap. And on the word plastic. Indeed, everything on the camera is plastic—including the lens—except for some metal clamps intended to hold the camera strap in place. (And which most smart photographers quickly replace with black duct tape.) As a result, light leaks are not only common, but expected, and the plastic lenses vary to such a degree that one of the key elements in any exposure is randomness. (Most photographers usually try to alter these design problems early on with a liberal application of black duct tape.) And you can purchase a brand-spanking new Holga today for around twenty-five bucks.

Tammy chose to eschew the precise image quality of her other cameras because she knew that her old Holgas would provide her with the emotional impact and concise directness that she knew would be needed. In addition, her husband, Scott (himself no mean photographer), modified some of the cameras to add greater flexibility to their inherent limitations. As a result, her portraits and scenes of Winona contain all the light streaks, lens flare, vignetting, variable focus, distortion, and movement that we come to expect of Holga images. However, they also contain an open honesty and a sense of conviction capable of advocacy for the victims they depict and the battles they fight.

Holgas have been used for years by serious artists and nouveau art geeks who have adapted their quirks to their own brand of post-modernism or minimalism. Tammy, however, was one of the earliest to realize that its personal "faults" could be utilized not only to relate the story of a human/environmental battle but to make the viewer feel it as well. It became an outstanding and important collaboration between technology and the human heart. Her final images are unremitting, evocative, persuasive, and unapologetically direct—everything that fine documentary photography and great art must be. Both they and the people they depict will never let you go.

One writer once called the Holga lens a "plastic imitation of glaucoma." The more I revisit Tammy's photographs, the more I am struck by how the lens's edge distortion always forces our misty gaze back inward toward her selected subjects. It looks like nothing so much as the way the world looks to any human being who is crying, whose sore and mist-filled eyes attempt to resolve all the visual elements they try to behold.

Tammy knows the secret of how her Holga holds a tear in the lens; of how the camera truly can weep for the photographer. And, in doing so, she also permits all of us the opportunity to weep: for Winona, for our nation—and, just perhaps, for all of humankind.

Fruit of the Orchard

Tammy Cromer-Campbell

I begin this story with a profound dream that changed my life. In 1993, I dreamed I was protesting with a group of courageous people from Winona, Texas, in a grassy field.

Background

Winona is a rural Texas community of 500 people living downwind of a toxic-waste injection-well facility built in 1982. Photographs of these residents reveal the tragic results many believe are associated with toxic emissions and contaminants from the American Ecology Environmental Services toxic-waste facility (formerly known as Gibraltar). The community was originally told that Gibraltar would install a salt-water injection-well facility and plant fruit orchards on the remaining land. Instead, trucks and trains from all over the U.S. and Mexico came to Winona to dump toxic waste into the open-ended wells. No fruit orchards were ever planted. It was not until 1992, when the residents began to fear the long-term effects of the various emissions and odors emanating from the facility, that Phyllis Glazer formed Mothers Organized to Stop Environmental Sins (MOSES). In March 1997, the facility announced its shutdown, citing continued opposition by MOSES as the reason.

Winona children suffer numerous health problems: birth defects, rare tumors and cancers, stunted growth, brain and liver damage, kidney malfunction and failure, skin discolorations, immune deficiencies, and chromosomal abnormalities (genetic mutations). Most residents attribute many unexplained illnesses and some deaths to the American Ecology facility.

My involvement with the Winona community

I first became involved with the Winona community in 1994 when MOSES asked me to photograph Jeremy pro bono. He was a poster child for its campaign to raise public awareness of the dangerous and toxic conditions believed to exist in Winona, and to garner public support for its intent to shut down the facility. As the fifteen-minute photography session progressed, I found myself becoming deeply concerned about what was happening to this community and its residents. Haunted by Jeremy's honesty, nearly a year passed before I called Phyllis Glazer to ask her to provide me with the names of other affected residents, so

11

that I could document their stories on film as well. Through the lens of a plastic Holga camera, I tell their story.

Tammy Cromer-Campbell

Jeremy's Family

Since the days of slavery, Jeremy's family farm has been passed down through the generations, and his was one of the few families successful in keeping the land prosperous. The family lived off the land: they ate the vegetables they grew; they raised their farm animals; and they drank the water from their well.

After Gibraltar began operations, Jeremy's family could smell chemicals in their home and in the clothes they hung out to dry, and could taste chemicals in their water. After Jeremy began to have convulsions, they came to believe that their land, animals, and well were all contaminated.

Jeremy's mother, Wanda, spoke out against the facility many times. One night on her way home, a trucker pulling out of Gibraltar forced her off the road and threatened her life.

Before they moved it, the ancestral farmhouse was two-tenths of a mile from the hazardous-waste facility.

The Smiley Family

The first family I photographed was the Smileys. The light was perfect as I journeyed to the family's home after work one evening in the fall of 1995. I photographed the children, then left with barely enough light left in the sky to view my surroundings.

On my way home, I became lost. To my amazement, I found myself in the same grassy field as my dream. It was then that I realized ... this project found me.

Linda and Stephen Smiley have three daughters. Kim, the eldest, was born healthy in 1981. Courtney, the middle child, is not so healthy. She was born in 1984, one year after the hazardous-waste facility began operations.

Courtney's many problems include unformed ears, webbed toes, numerous tumors on her cervical spine that had to be removed, and skin and respiratory problems. In 1998, Linda told me that the doctors believe that Courtney has three kidneys. I spoke with Linda in September 2000. She told me that Courtney, a senior in high school, had another tumor on her cervical spine that needed to be removed. Courtney wanted to finish her senior year and then undergo the painful surgery. Waiting placed Courtney at risk.

Stephanie is the youngest, and she was abnormally small for her age. She, too, suffers from skin disorders and respiratory problems.

The Cooper and Jones Family

Jamesia Cooper and Bianca Jones are cousins living in Winona, Texas. They both were conceived in Winona. Jamesia was conceived less than two miles from the facility. Jamesia suffers from albinism, has respiratory problems, and is photosensitive. Bianca suffers from an undiagnosable skin disorder that leaves her skin splotchy and very dry. Her grandmother told me that many doctors have prescribed different treatments for Bianca's skin disorder, but they do nothing more than burn her skin. Bianca also suffers from respiratory problems.

On the day that I photographed Jamesia, her grandmother, Georgia Jones, told me that Jamesia would not be able to go on the school field trip to the zoo the next day, because she is photosensitive and burns very easily in the hot East Texas sun.

Wasted Babies®

In 1995, the mothers and grandmothers of MOSES began making Wasted Babies®. The handmade dolls are symbols of Winona's plight, and are given to the media and public officials and sold to the public to help garner support. The card attached to the doll reads:

"Your doll represents a sick child, a wasted baby. The doll is modest ... may be light or dark—so are the children who have been impacted. The doll is not a toy to be played with and discarded—neither are the children your doll symbolizes. Winona is a small place and the disposal of hazardous waste is a big problem. Some believe that Winona's destruction is an acceptable risk ... Wasted Babies are only dolls that cannot walk, talk, or even cry for the children they symbolize—but you can give them life through your actions."

Michael Williams

Michael Williams is diagnosed with a mutated form of neurofibromatosis (elephant man's disease). Michael loves horses.

Michael's mother was very vocal about the problems she thought the facility caused. Michael once had his own horse, but it was mysteriously shot. The horse he is sitting on in the photograph belongs to his mother.

Amanda Clark

Amanda (Mandy) Clark and her family are very private people. Mandy was diagnosed with Hodgkin's disease, and at first, she did not want her picture taken. In the end, however, she kindly allowed me to take one roll of her.

Amanda Clarke died at the age of eleven on October 5, 1997, from complications of her disease.

The Jackson Family

Deon Jackson lives near Winona in the Waters Bluff area. He was born with his kidneys outside his body. Deon is photographed with his mother, Denise, and Reginal, his brother.

The Shaddox Family

Joey and Sharon Shaddox purchased an old farm and farmhouse on a picturesque hilltop and rebuilt the 100-year-old home board by board. They loved their farm, but chemical smells began to envelop it.

Now Katie Shaddox has become chemically sensitive. She is so chemically sensitive that she cannot attend public schools or church.

Katie's mother, Sharon, began keeping a packed bag at the door, just in case they needed to evacuate to their safe house near Dallas because of the chemical odors.

The Hoyne Family

Originally from Ireland, the Hoynes moved to Winona, their newfound Ireland, to build their dream home and raise their family. They did not know that a commercial hazardous-waste facility was less than a mile from their home. Lillian, the mother and a registered nurse, did everything right with her pregnancy. Her son, Douglas, was born with a mutated chromosome 15, which causes severe learning disabilities. Doctors told them that it is one of the rarest chromosomal problems in the country. The family moved to Bellmore, New York, because it had the best school system for Douglas. The Hoynes have two other children. While I was visiting their home, the youngest looked at me and said, "Texas scares me."

Douglas died on the morning of May 24, 2000. His parents tried to wake him, but he would not wake. Cause of death is unknown. Douglas Hoyne was seventeen years old.

Stricken with grief, his parents wanted to build a special memorial for Douglas. They struggled to come up with a suitable idea. They were discussing their ideas with a group of adults when Douglas' thirteen-year-old brother said, "I would like to build Douglas a gazebo

Tammy Cromer-Campbell

for my Eagle Scout project at his favorite spot on Wantagh Park." Everybody stopped talking and stared at the thirteen-year-old with bewilderment and amazement. Then they decided that is what they must do. Money and supplies poured in for Douglas' Gazebo.

MOSES at the Stand for the Children Day rally in Washington, DC

MOSES chartered a bus for fifty-five people (mostly children) to travel to Washington, DC, for the Stand for the Children Day rally on June 1, 1996. This was the group's second trip to the nation's capital. East Texas native, environmentalist, and legendary rock and roll musician Don Henley funded the first trip in 1994.

Phyllis Glazer lined up congressional meetings so that the Winona residents could tell their stories. MOSES made such an impact on the House of Representatives and the Senate that the group was asked to stay longer in order to meet with the White House Executive Office of the President of the United States Council on Environmental Quality.

The Adams Family

While Denise Adams was pregnant with her youngest child, Vickie, she drove through a cloud in front of the Gibraltar facility. Shortly thereafter, she went into labor and Vickie was born prematurely. Vickie now suffers from respiratory problems. Penny, the oldest child, also suffers respiratory problems.

Charlie and Virgie were the most loving couple I knew. They always were together. Charlie also had a great sense of humor. He always made me smile, except for this day. On this day he was diagnosed with lung cancer for the second time. Charlie was also a very courageous man. He invited me into his life during a very difficult time. I think it was his way of fighting back. He died on August 10, 1998. Virgie was MOSES' first secretary, and both were very strong supporters of MOSES. Virgie continues to be actively involved.

Others Affected

After a 1992 explosion, Miriam Steich's breast began lactating, and her chickens stopped laying eggs.

Winona, Texas

Winona, Texas (population 457), is approximately ninety-six miles east of Dallas and ninety-six miles west of Shreveport, Louisiana, off Interstate 20. A demographic analysis prepared in 1999 by Robin Saha and Paul Mohai of the University of Michigan concluded that "rela-

15

tively high minority percentages, low incomes, and high home ownership suggest that residents living near the facility may face significant barriers to moving elsewhere, due to housing discrimination, household finances, neighborhood attachments, and potential difficulties selling their homes."

Winona's Activists

MOSES had many supporters, including Tommy, who rode his bicycle to the meetings. Tommy was a very special person with the mentality of a child, yet he was capable of caring for himself. Tommy's stature was very large with his skin as black as coal, but his spirit was gentle and noble. One of Tommy's favorite things to do, besides singing in the choir, was to work with Phyllis Glazer and MOSES. He decided one of his jobs was to be Glazer's bodyguard and he took that job very seriously. Here is an excerpt from his funeral program: "Tommy's sunrise was September 1, 1963, and his sunset was February 8, 2006." Phyllis, her mother, and I attended the funeral or "A Homegoing Celebration" for Tommy Lee Bland, Jr., on Saturday, February 11, 2006, at New Zion Baptist Church in Winona, with Dr. S.L. Curry officiating. Many will miss Tommy's gentle spirit. The hospital said that Tommy's cause of death was an embolism, but no autopsy was performed.

Another activist, Phyllis Glazer's former gardener, Charles Sharpe, now is one of MOSES' strongest supporters.

Linda Smiley told me about her sister-in-law, Pat McGaughey. Pat was Winona's first activist for the cause, and formed the Concerned Citizens of Winona/Owentown in 1986. She died when her car collided with a train in 1988. Months after Pat's death, her mother received a phone call consisting of nothing more than a train whistle.

Karen Silkwood

I think it is ironic that Karen Silkwood is buried 20 miles east of Winona in Kilgore, Texas.

Silkwood was a nuclear-plant worker at Kerr-McGee in Oklahoma. She was a member of the Oil, Chemical, and Atomic Workers Union. Her first assignment as Kerr-McGee's first female member of the union bargaining committee was to study health and safety issues at the plant. According to the *Handbook of Texas Online*, Silkwood "discovered evidence of spills, leaks, and missing plutonium ... (and) testified to charges before the Atomic Energy Commission that she had suffered radiation exposure in a series of unexplained incidents. On November 13, 1974, she was killed in an automobile crash while on her way to meet with

an Atomic Energy Commission official and a *New York Times* reporter ... Speculations over foul play in her death were never substantiated ... Her case, which began in 1974, emphasized the hazards of nuclear energy and raised questions about corporate accountability and responsibility."

Phyllis Glazer

Phyllis Glazer stayed in Winona as long as she did because she had a mission. She told me in her whimsically feisty way, "a mission from God!"

In the October 19, 1997, *Texas* magazine, *Houston Chronicle* reporter Clifford Pugh described Phyllis Glazer as an "apolitical housewife" turned into an "environmental activist" with an unstoppable mission in Winona, Texas. Glazer depleted her inheritance to save the poor minority community in which she lived. Her father escaped the Holocaust and he instilled in his daughter the preciousness of life and liberty. She had the financial resources to leave the community, but chose instead to stay and fight.

Glazer utilizes innovative and bold strategies to further the cause of MOSES. She created Wasted Babies® as a project to help educate the public about Winona's problems and to prevent them from ever happening again anywhere else.

To this day, Glazer conducts her environmental crusade from her home and has established MOSES' new headquarters in Dallas, Texas. She continues to meet with government officials and the media and makes television appearances. In December of 2000, Phyllis Glazer was diagnosed with a brain tumor and received treatment to stop the growth in February 2001, with a Gamma Knife procedure. I was with her when she came out of the procedure. While in recovery Phyllis looked at me and said, "I am going to sue EPA with a Title VI[1] lawsuit." I knew then that Phyllis was going to be fine.

Phyllis Glazer is a truly remarkable woman.

U.S. Environmental Protection Agency Office of Civil Rights

As a result of the Title VI lawsuit that Glazer filed, the United States Environmental Protection Agency (EPA) Office of Civil Rights furnished MOSES this investigative report.

"The evidence in this case strongly suggests that the residents of Winona suffered repeated and acute health impacts throughout the time that the Gibraltar facility was in operation ... The record is heavy with reports of nausea, dizziness, rashes, and respiratory distress at times that coincided with odor events at the Gibraltar facility. The reported symp-

toms and reactions are consistent with those of chemicals known to have been present at the Gibraltar facility during the time of its operation ...

"In addition, there is a continuing potential for exposure to residual contamination in groundwater used for drinking, due to the possibility of off-site migration of wastes."[2]

Tammy Cromer-Campbell ____

1. Title VI of the Civil Rights Act of 1964 is a federal law that prohibits discrimination on the basis of race, color, or national origin in all programs or activities receiving federal financial assistance. Title VI itself prohibits intentional discrimination.

2. Because this investigation is a non-adversarial process, the information and evidence relied on is not subject to rules of evidence or procedure that would apply in, for example, a civil judicial action. This is an administrative investigation intended to assess whether a state recipient of federal financial assistance is complying with federal law and EPA regulations at 40 C.F.R. Part 7, and whether any corrective action is needed or appropriately undertaken by the recipient based on the results from the investigation. The evidence and concomitant conclusion(s) are intended solely for that purpose. See, *e.g., Federal Maritime Common v. South Carolina Port Auth.* No. 01-46 (U.S. Sup. Ct. May 28, 2002), Slip Op. at 23 (distinguishing between administrative adjudication and administrative investigation of a state entity by a federal government agency).

Plates

Plate 1 Jeremy

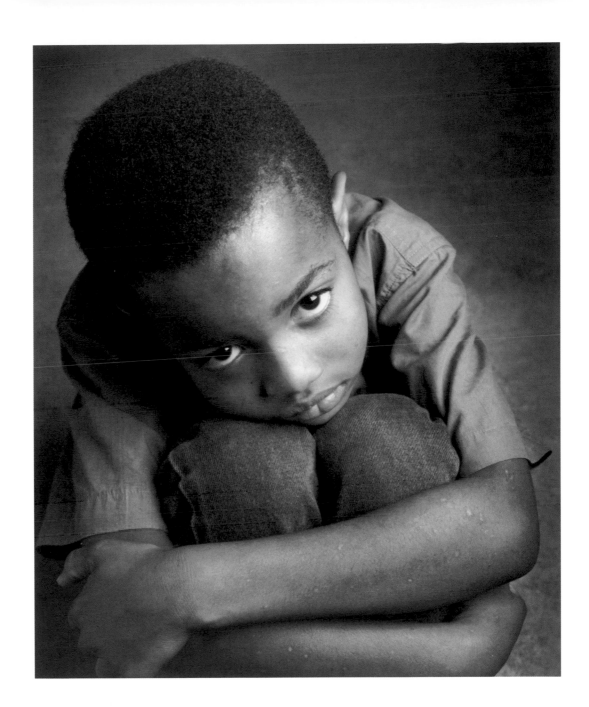

Plate 2 Stephanie and Courtney. 1997

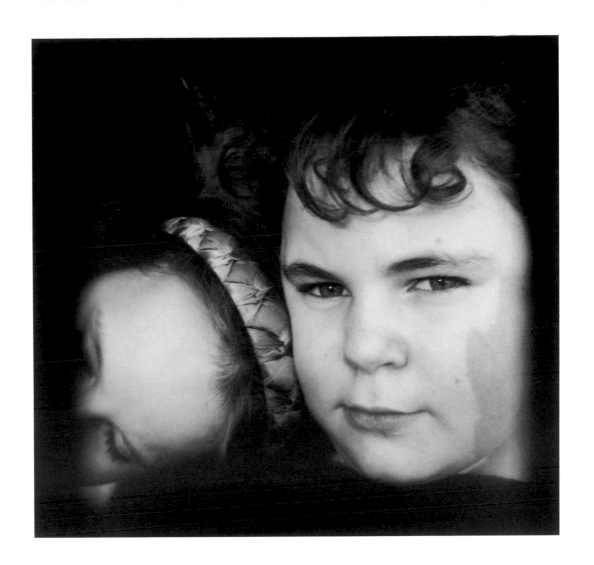

Plate 3 Courtney's webbed toes. 1995

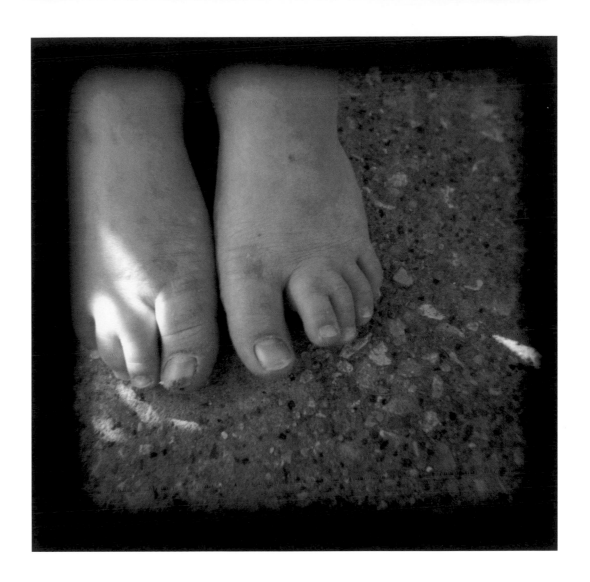

Plate 4 Courtney's latest scar and her mother Linda Smiley. 1996

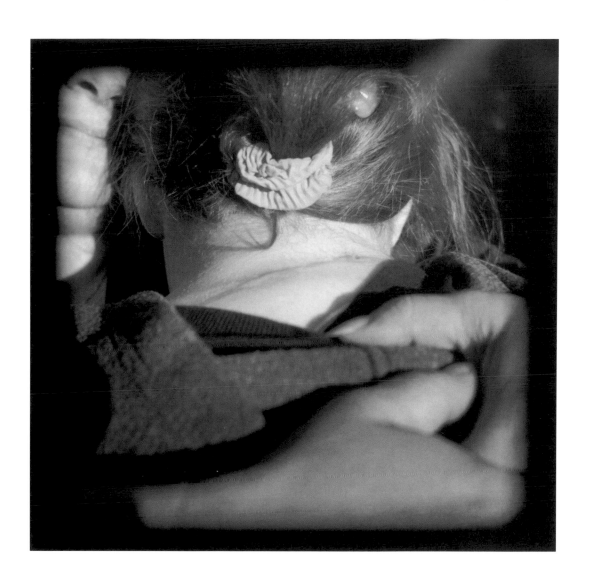

Plate 5 Fruit of the Orchard. 1997

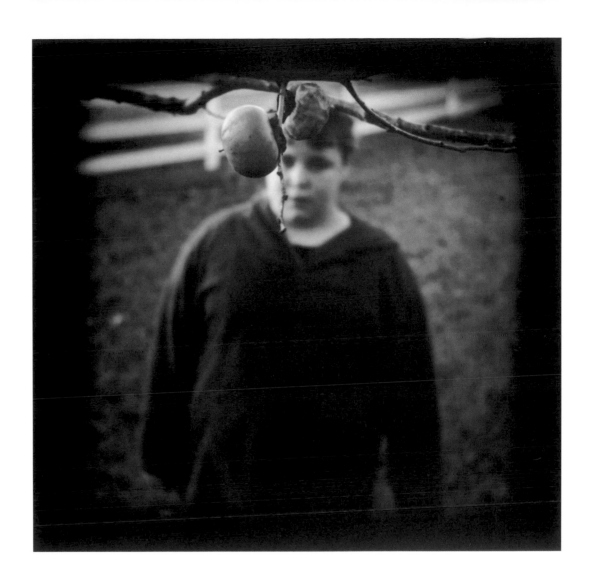

Plate 6 Stephanie looking up. She is also abnormally small for her age. 1995

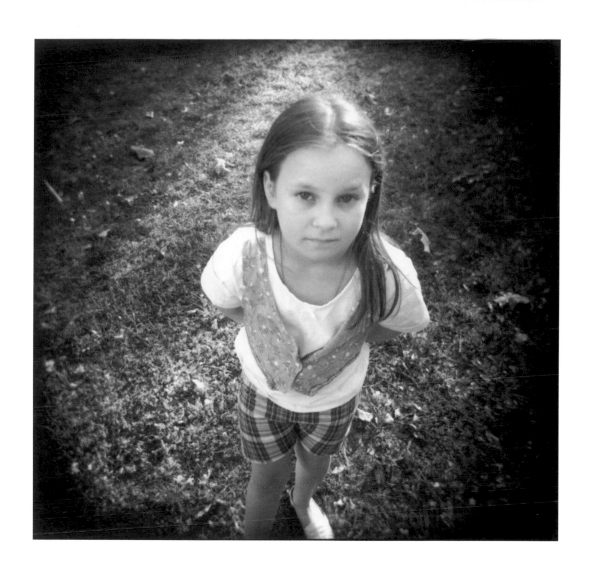

Plate 7 Jamesia and Bianca laughing. 1995

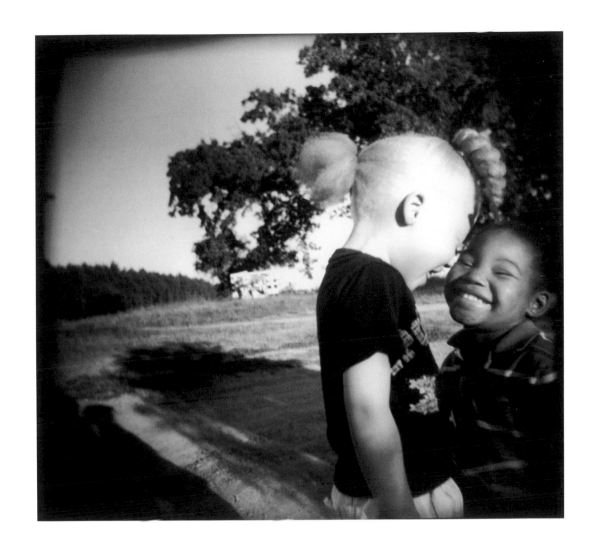

Plate 8 Jamesia and cousins. 1996

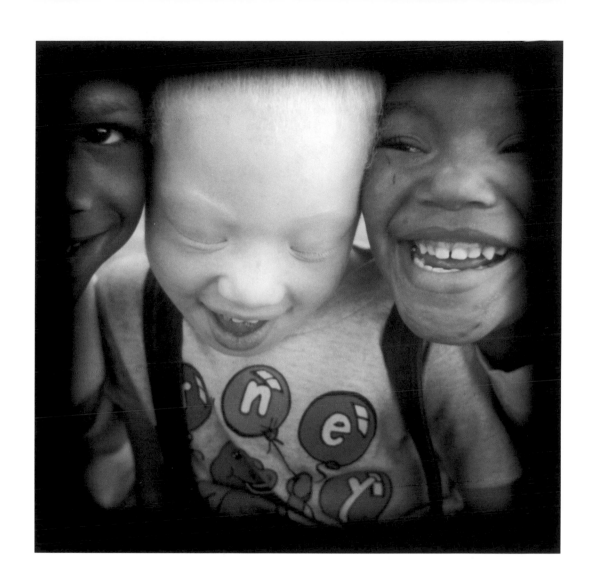

Plate 9 Jamesia's first home. 1996

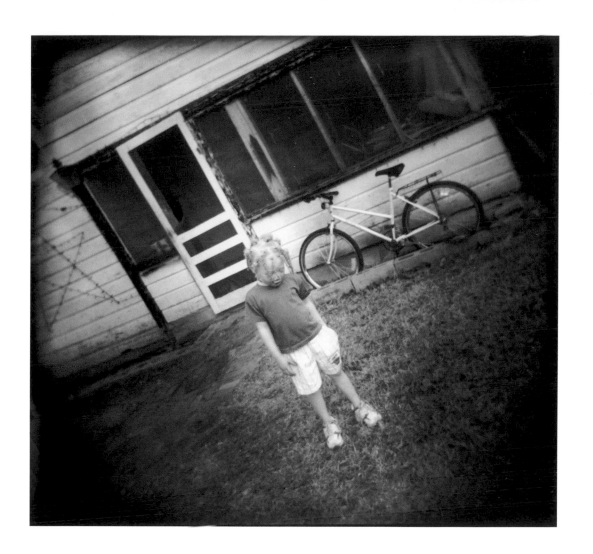

Plate 10 Hands with crackers. 1996

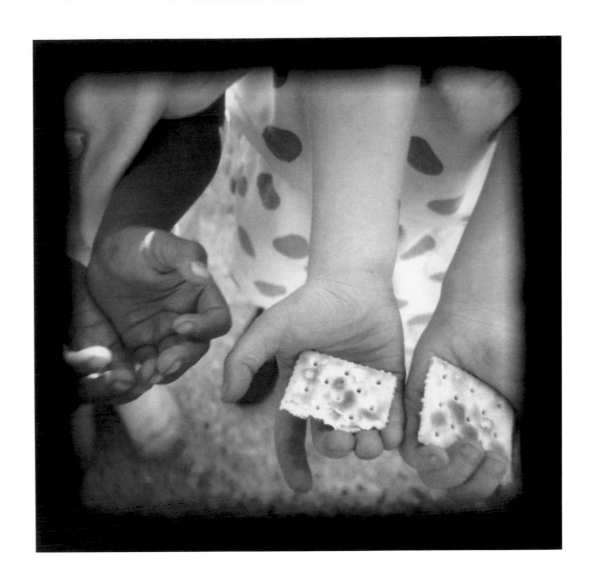

Plate 11 Georgia Jones and grandbabies. 1996

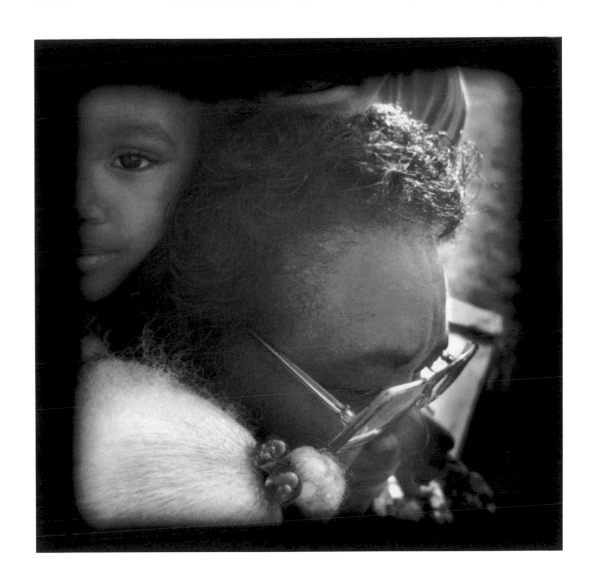

Plate 12 Environmental Justice Now. 1995

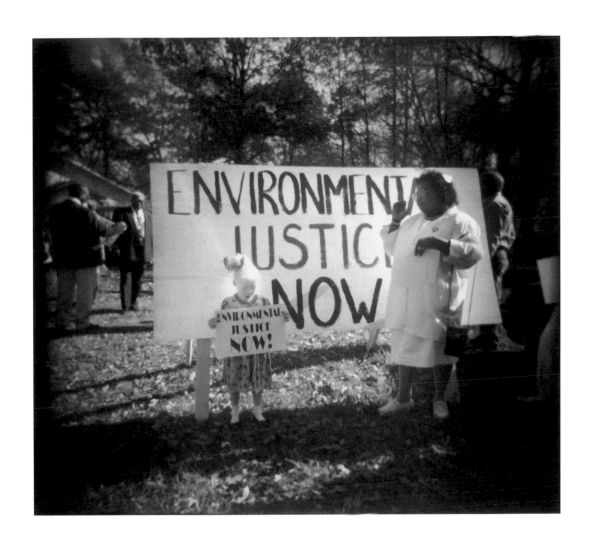

Plate 13 Wasted Babies® and Jamesia. 1995

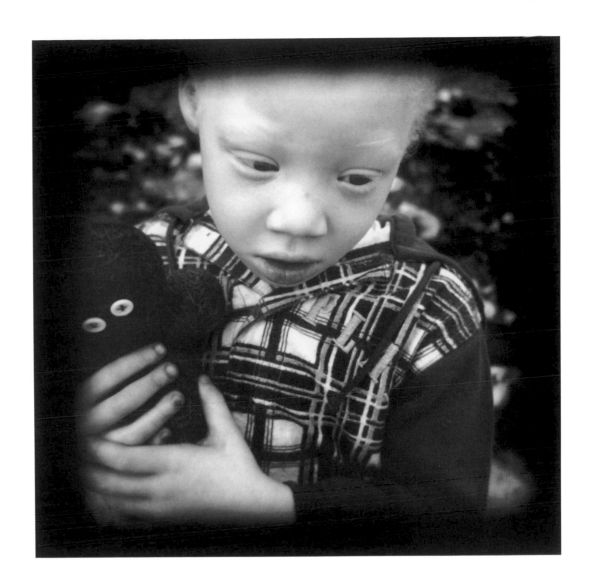

Plate 14 Michael Williams. 1995

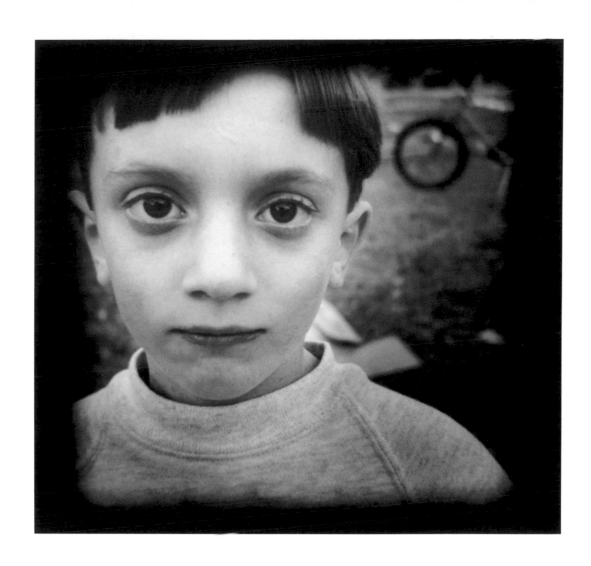

Plate 15 Michael's egg. 1996

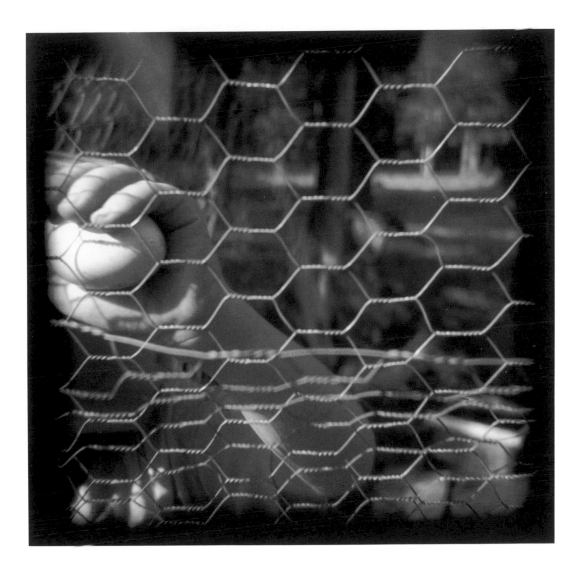

Plate 16 Michael on horse. 1996

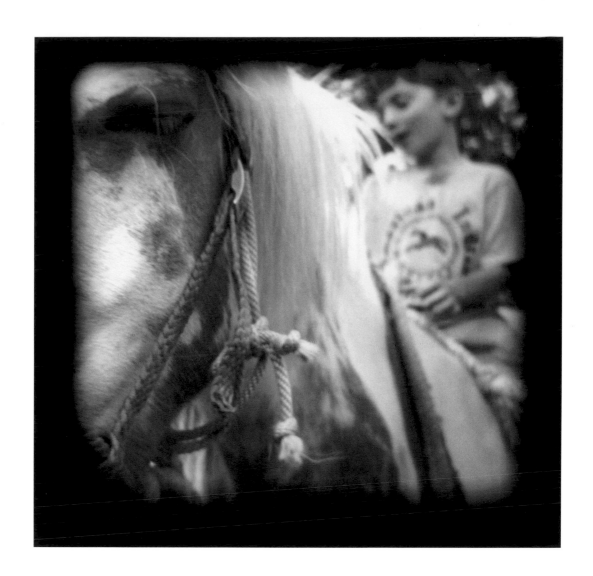

Plate 17 Michael with awards. 1996

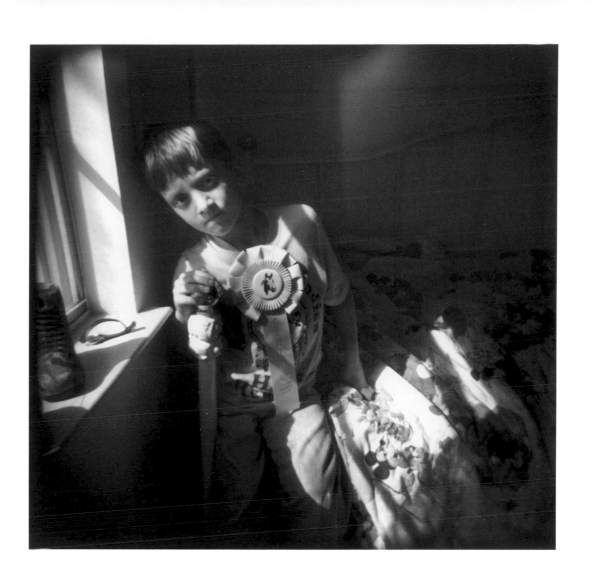

Plate 18 Amanda Clark. 1996

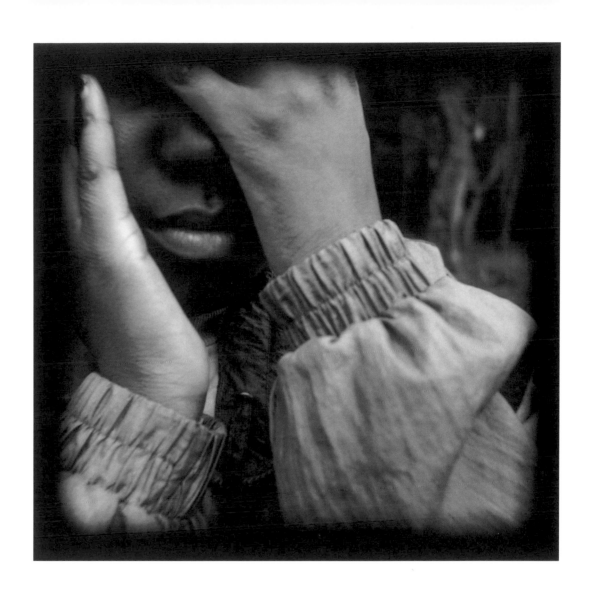

Plate 19 Amanda Clark's grave, April 1999

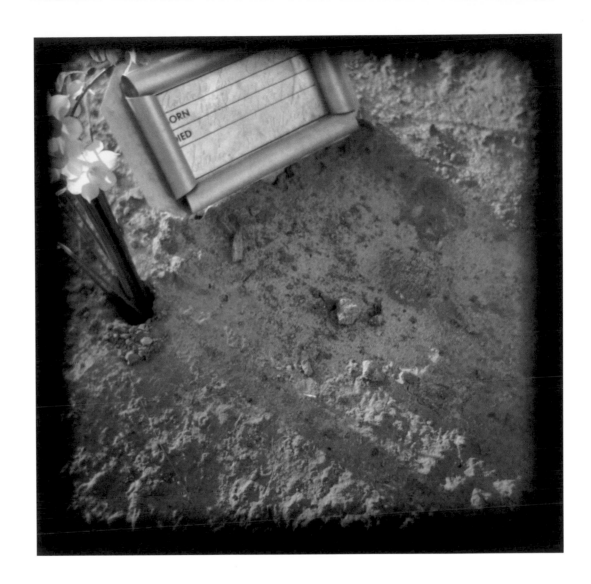

Plate 20 Deon, Denise, and Reginal Jackson. 1997

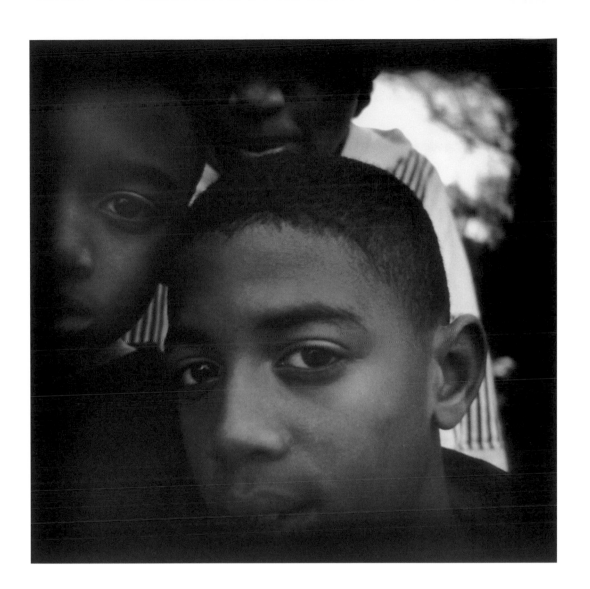

Plate 21 Katie Shaddox. 1997

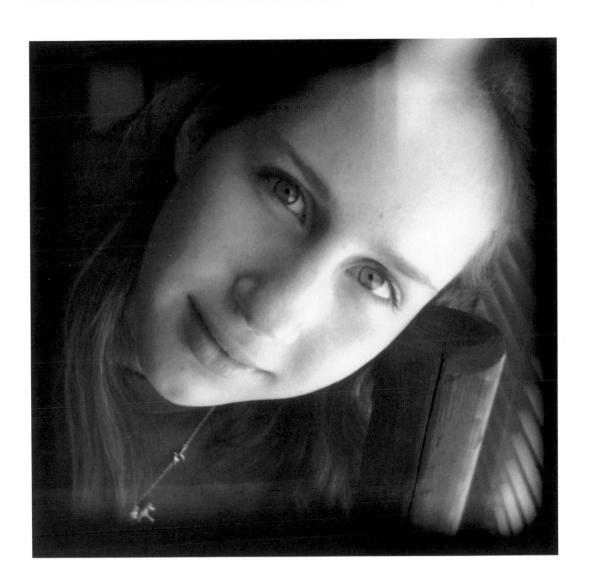

Plate 22 Cassie Shaddox feeding calf. 1998

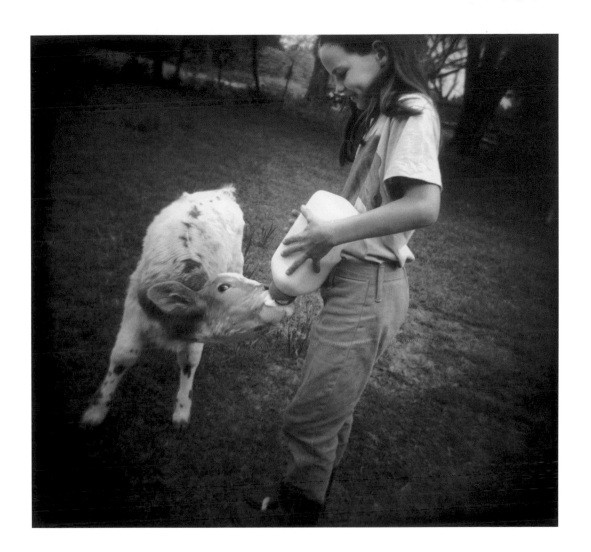

Plate 23 Katie Shaddox and Wasted Babies.® 1995

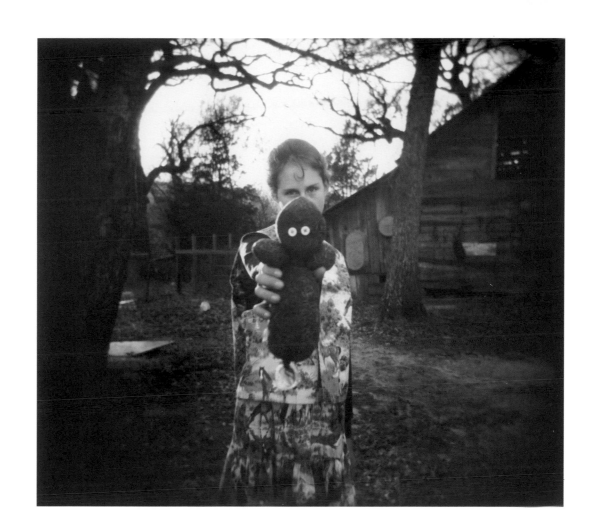

Plate 24 Douglas Hoyne, age thirteen, Bellmore, New York. 1996

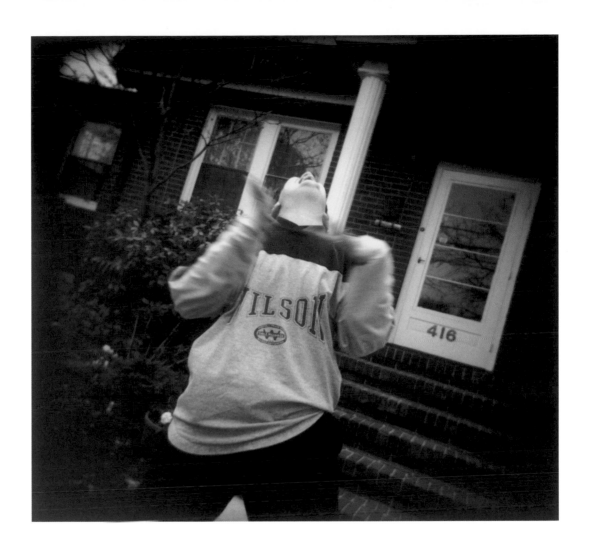

Plate 25 Douglas' gazebo

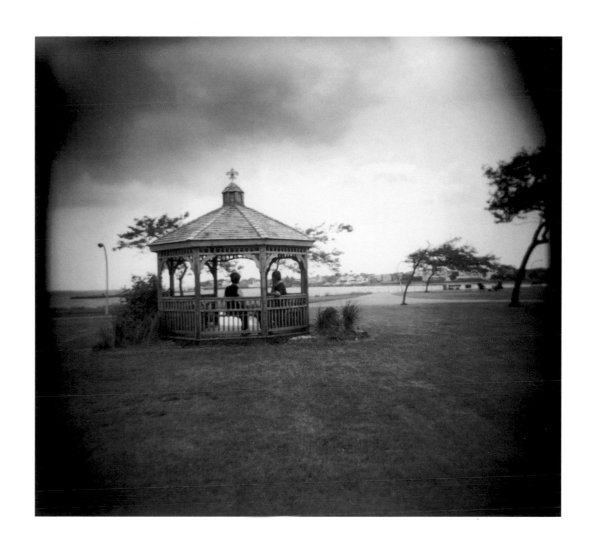

Plate 26 Jamesia and others during the bus trip to Washington, DC. 1996

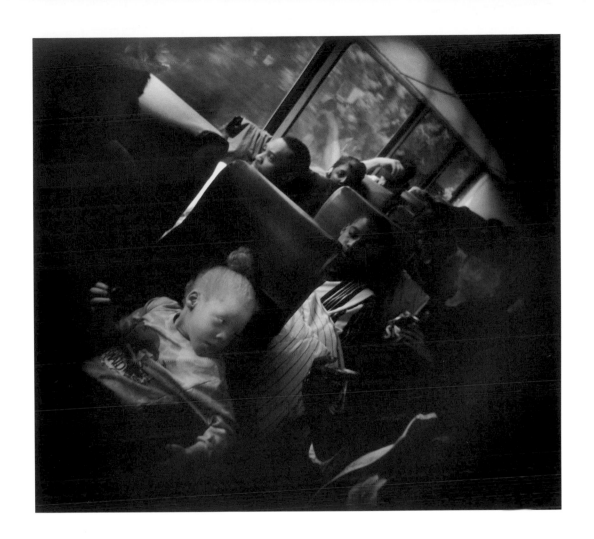

Plate 27 MOSES group in the halls of Congress, Washington, DC. 1996

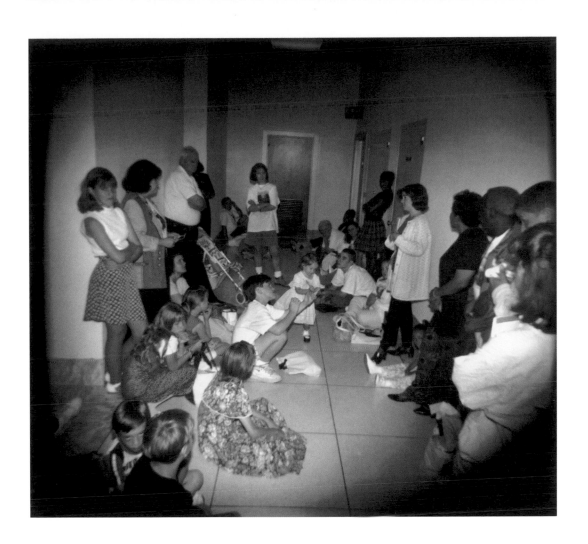

Plate 28 Patrick and Douglas Hoyne and other members of MOSES leaving the Environmental Protection Agency (EPA) in Washington, DC. 1996

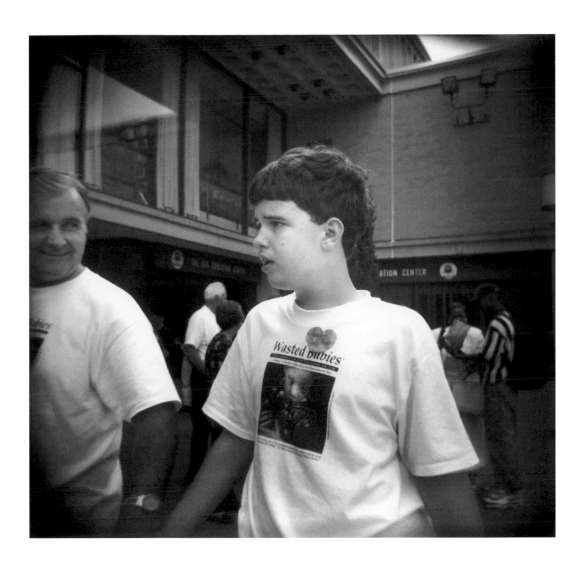

Plate 29 Invitation to the White House. 1996

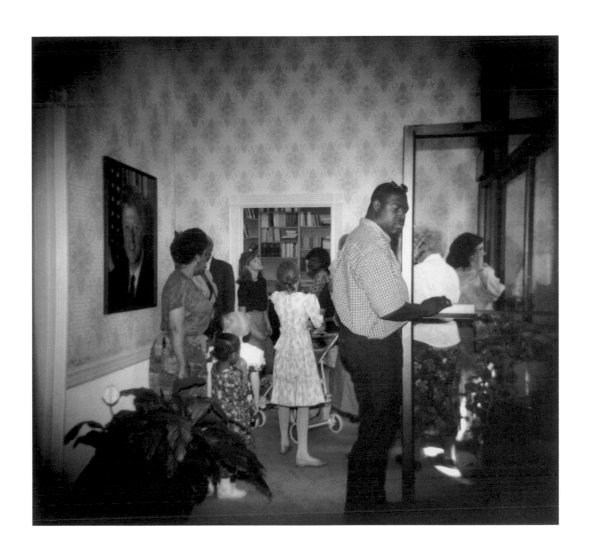

Plate 30 MOSES at the U.S. Capitol. 1996

Plate 31 Michael Williams and Phyllis Glazer. 1996

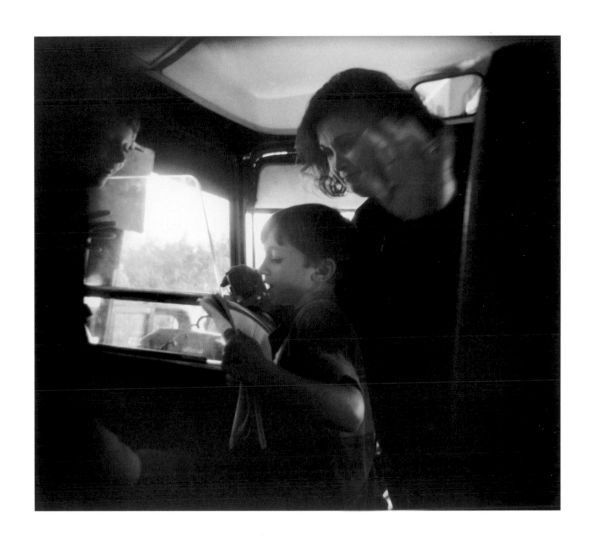

Plate 32 Penny Adams during the bus ride home from Washington, DC. 1996

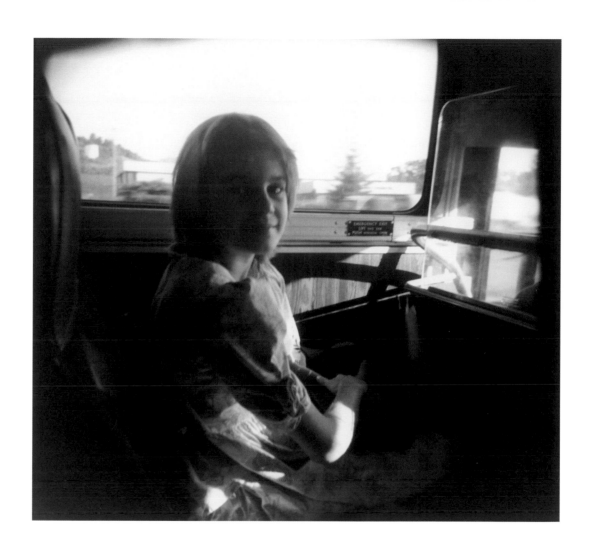

Plate 33 Denise Adams with children. 1995

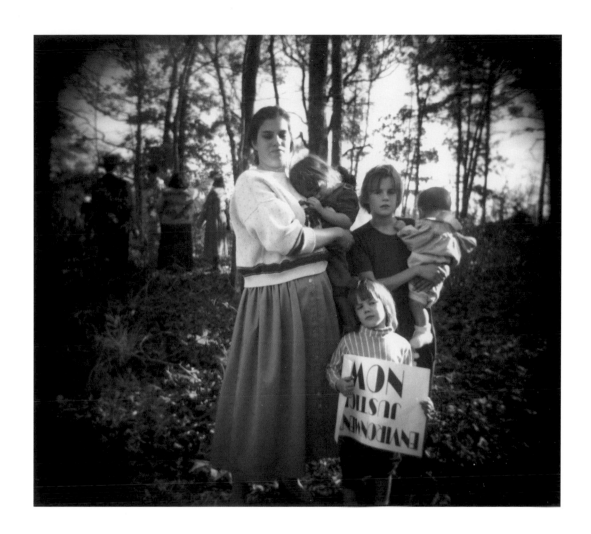

Plate 34 Virgie and Charlie Adams. November 13, 1997

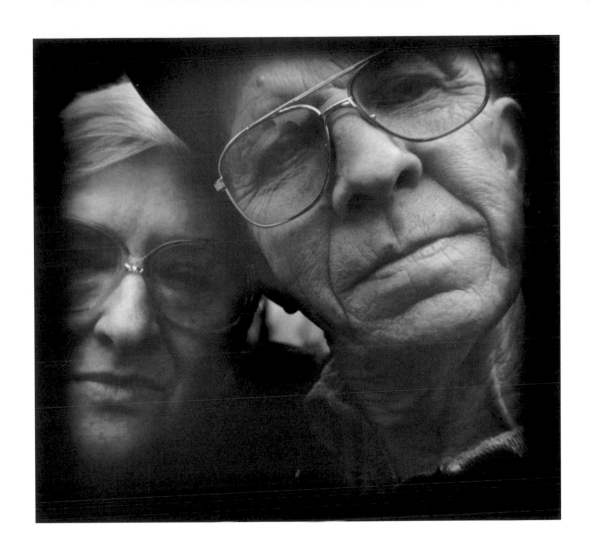

Plate 35 Virgie Adams' wedding rings. May 4, 1998

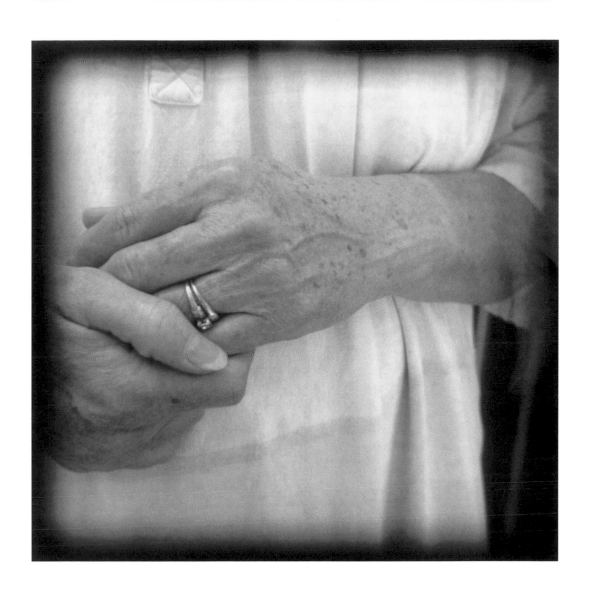

Plate 36 Virgie kissing Charlie Adams. July 27, 1998

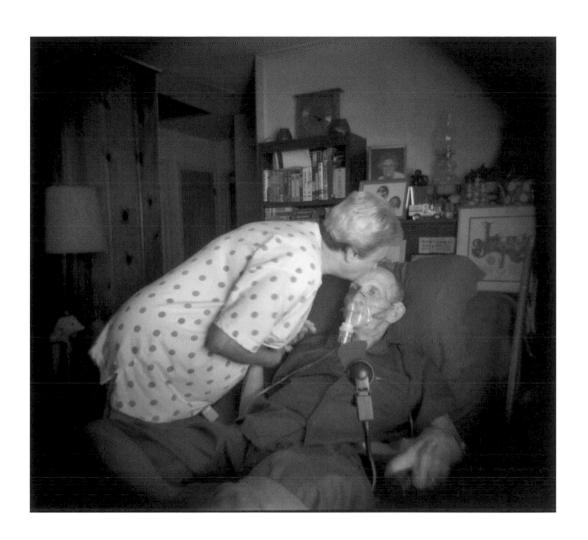

Plate 37 Charlie Adams' funeral. Keith Adams sits with his father. August 13, 1998

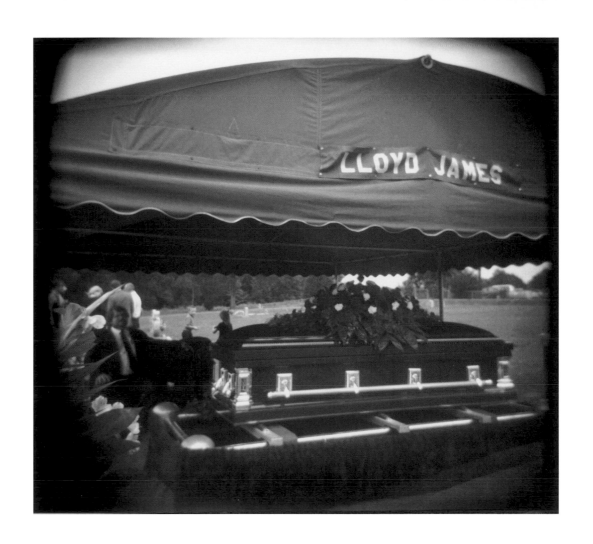

Plate 38 Miriam Steich's hands on her breast. 1998

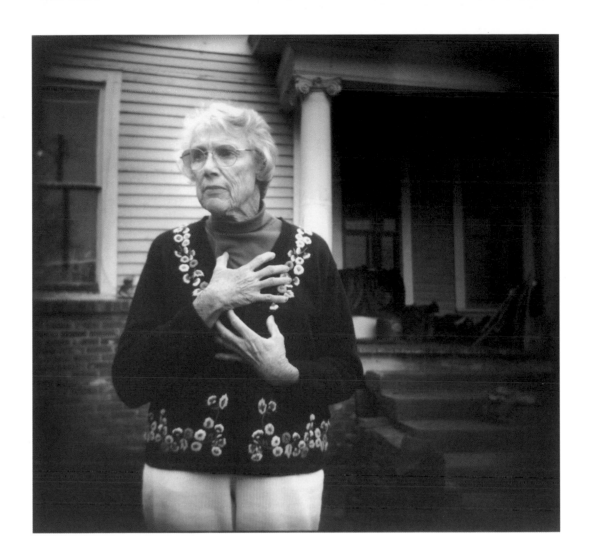

Plate 39 Downtown Winona

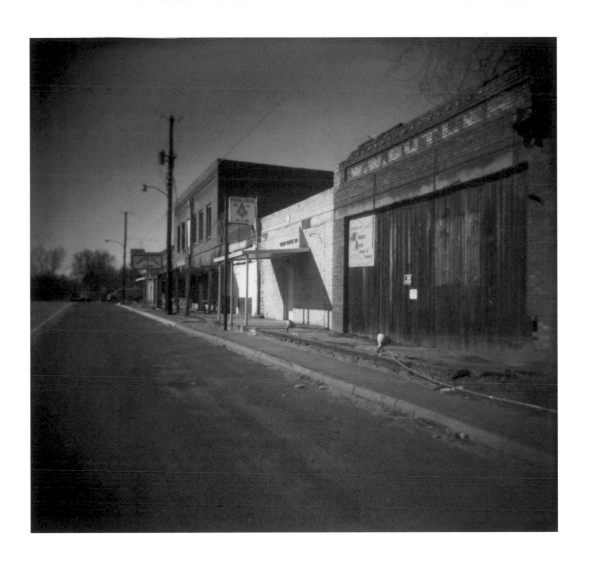

Plate 40 Aerial view of Winona, Texas. 1999

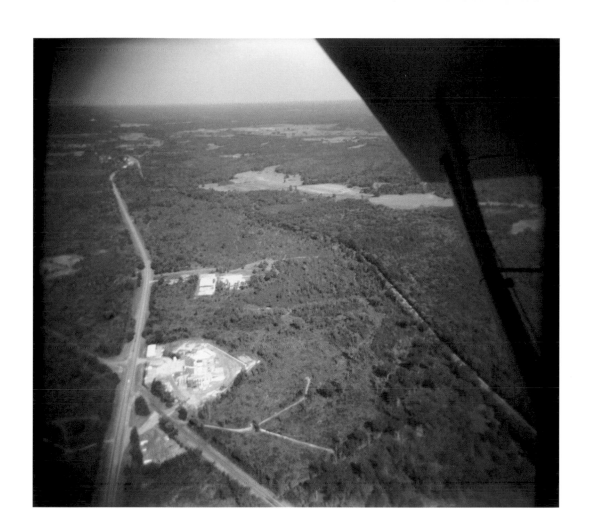

Plate 41 Plant entrance. 1996

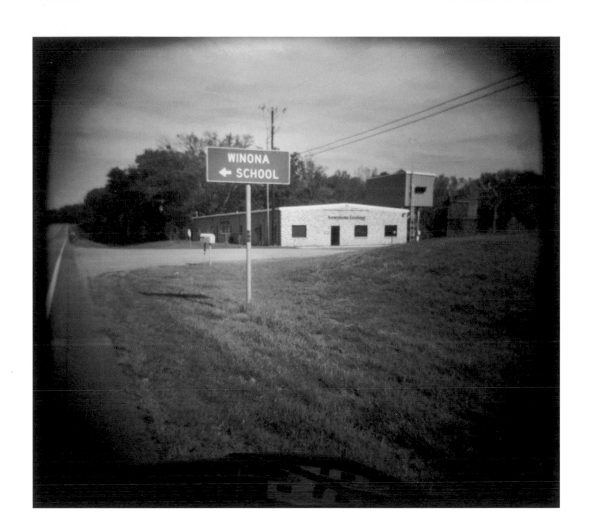

Plate 42 American Ecology Thermal Oxidizer facility in Winona, Texas. October 1996

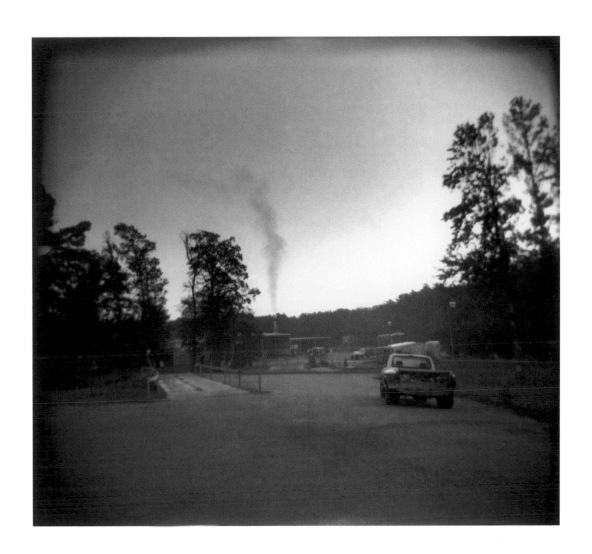

Plate 43 Tommy attending a meeting of the Texas Natural Resource Conservation Commission (now the Texas Commission on Environmental Quality). 1997

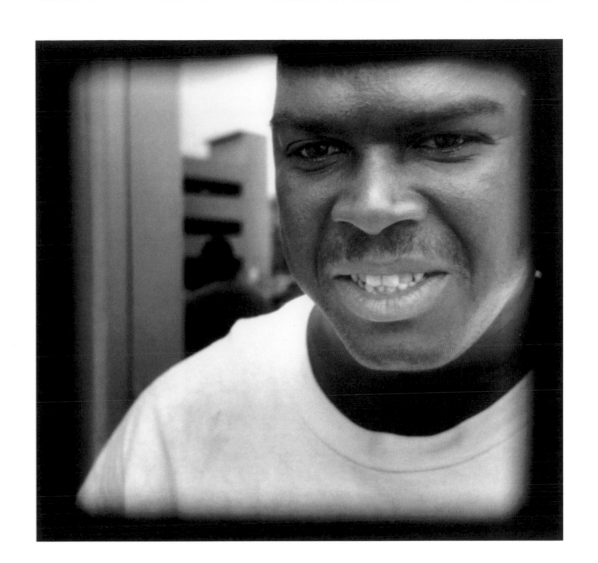

Plate 44 Tommy's homegoing kiss. 2006

Plate 45 Charles Sharpe attending a Texas Natural Resource Conservation Commission
(now the Texas Commission on Environmental Quality) meeting. 1997

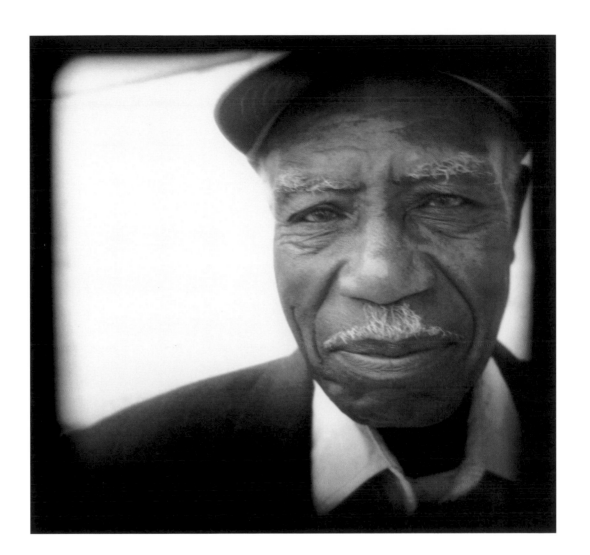

Plate 46 Wasted Babies® in Washington, DC. 1998

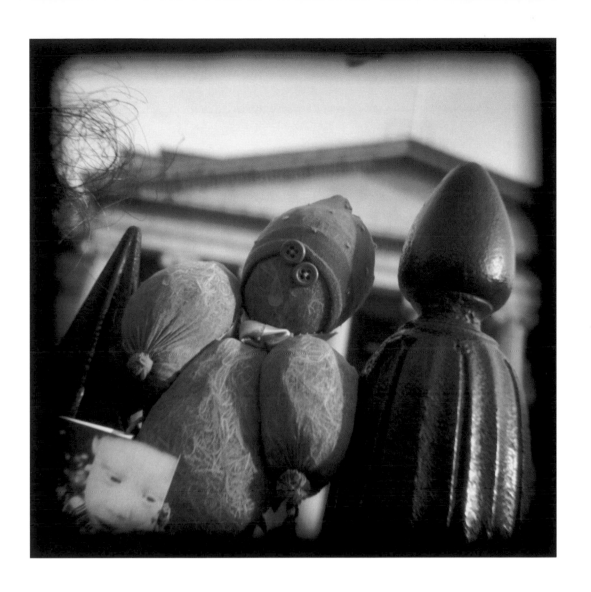

Plate 47 Pat McGaughey. 1998

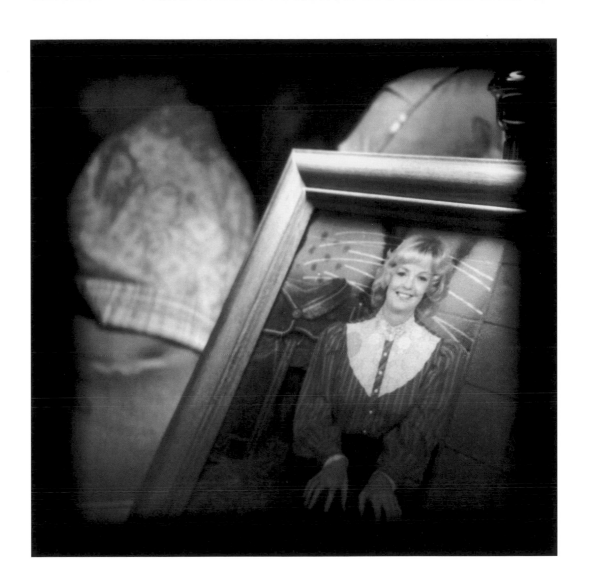

Plate 48 Karen Silkwood

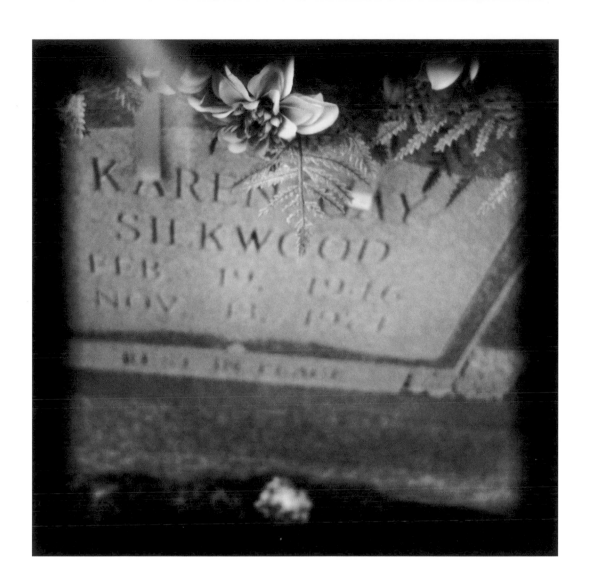

Plate 49 Phyllis Glazer in action at the Environmental Justice March. 1995

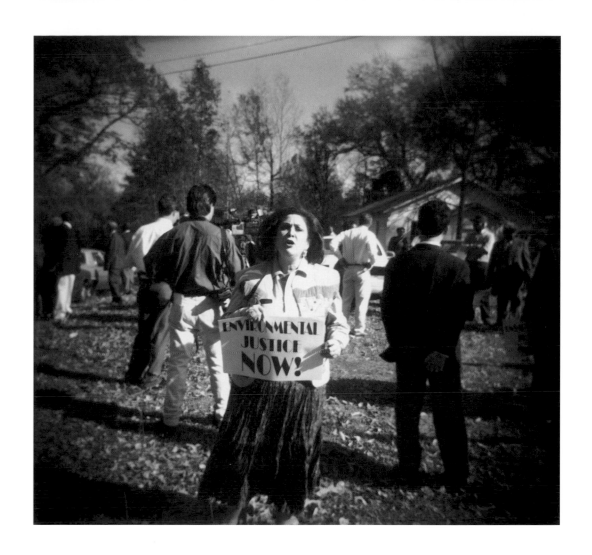

Plate 50 Phyllis Glazer making Wasted Babies® during the bus ride to Washington, DC. 1996

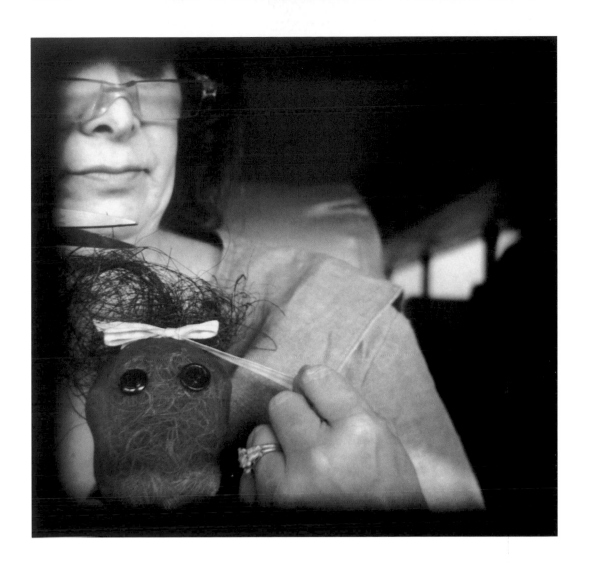

Plate 51 Phyllis Glazer and Bianca. 1997

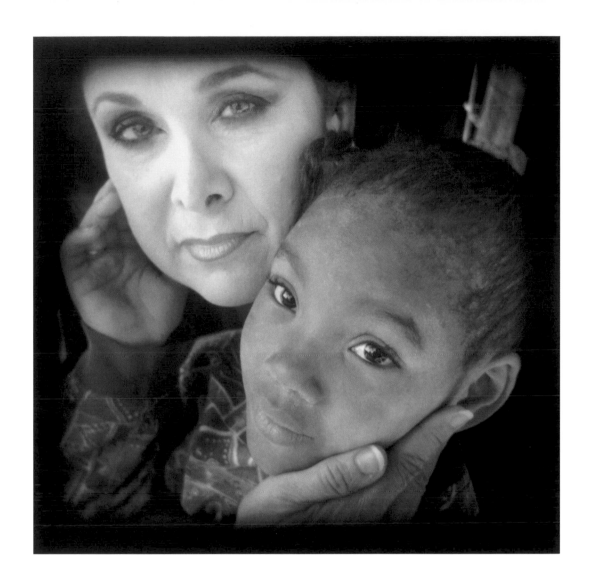

Preventing Future Winonas

Dr. Eugene Hargrove

The Limits of Environmental Justice in the United States

Concerns about environmental justice and environmental racism are usually focused on large population centers, and more specifically on the poor urban neighborhoods in which the majority of the residents are minorities, usually black or Hispanic. The Environmental Protection Agency is currently looking into ways to deal with these environmental justice issues, focusing on the identification of problem areas. In these surveys, industrialized sites in urban areas stand out starkly in comparison with rural areas. Sadly, small towns do not end up even as a blip on the radar scope in these surveys. Moreover, given that the EPA efforts are underfunded, the agency has no significant resources to devote to places like Winona.

Overcoming the Burden of Proof: Proving Harm

Once damage has occurred, the only course of action is usually legal, either to try to stop the pollution if it is ongoing or to seek compensation. Winning, however, is difficult because it is hard to demonstrate a causal connection between the actions of the alleged polluters and the alleged damage to human health, property, and the environment. Consider smoking and lung cancer. Smoking is a necessary, but not a sufficient, cause of lung cancer. It is a necessary cause because most people who have lung cancer also turn out to be smokers. It is not a sufficient cause, however, because there are also many people who smoke all of their lives without getting cancer. As a result, it is easier to explain the cause of lung cancer after someone has it than to predict that any particular person will get it. The case for smoking as a cause of lung cancer, nevertheless, is very strong because over many decades in the twentieth century statistics became available showing that most people who developed lung cancer also smoked. These kinds of statistics, however, are generally not available in air and water pollution cases. Usually there is not a single contaminant involved, but rather a mix of contaminants, and the mix of contaminants may vary from site to site.

Dr. Eugene Hargrove is Editor of *Environmental Ethics*
Founder of the Center for Environmental Philosophy
Professor at the University of North Texas in Denton

One might suppose that since there are governmental standards specifying how much of any contaminant is permissible, these standards could be applied as facts in legal actions to demonstrate casual connections between pollutants and damage to human health, property, and the environment. However, these standards are usually at best estimates or guesses, not the results of thorough scientific investigation. For example, in developing standards for radon gas in homes for the EPA, Crawford-Brown and Pearce found that "The available inferences of the risk of radon in water ranged over values which differed by a factor of 1,000, including the possibilities that the existing radon was producing no risk or was beneficial."[1]

Obviously, standards based on the kind of guesswork involved in the radon gas case are not likely to be very stringent. They cannot be set so high that they will place an inordinate financial burden on the contaminators. A high standard based on weak evidence and theories would be successfully contested in court.

The situation is similar in litigation between a polluter and a community that believes it has been damaged by one or more contaminants. The community might be able to show that the polluter was releasing something disagreeable into the air or water. However, conclusively showing the link between the pollution and the damage to the health, property, and environment would be much more difficult and likely impossible within a reasonable period of time, especially in the case of multiple contaminants.

In Winona, the health argument was especially difficult because the polluter was a toxic waste facility that was not releasing a specific set of contaminants into the air and water. Rather, the contaminants came from a wide variety of materials released through accidents at the facility, and it was therefore difficult to establish just what the community was exposed to, in what amounts, and for how long. As a result, Winona's most compelling argument was the photographs in this book.

Lowering the Burden of Proof: Aesthetics and Enjoyment of Property

Although the health argument is the strongest, it is also the most difficult to prove. As a result, in some cases it may be more effective to use a weaker argument that can be more easily documented and defended. For example, residents of Winona often speak of a large orange cloud of gas that floated out of the facility and enveloped houses nearby. Concern naturally focused on the possible health problems that the cloud could cause, since the cloud came from a *toxic waste* facility. However, other concerns could also have been appropriate.

For example, it would not have been difficult to show that the cloud originated at the facility, that it was an aesthetic affront, and that it diminished property owners' use of their property. Some years ago the City of Garland, Texas, tried this approach with an air pollution problem within the city. This problem involved emissions from a paint factory. Before the problem arose the city amended its definition of air pollution to include interference "with the normal use and enjoyment of animal life, vegetation or property."[2] In addition, the city revised its ordinances to include the same phrase.[3] This phrase extends pollution beyond matters of injury to include aesthetic issues as a right of property owners.

Suspecting the paint factory was the source of the emissions, the city studied the emissions from the stack, identifying twenty-two different contaminants. When complaints arose, the health department dispatched a truck to the site of each complaint to take air samples. Testing of these samples confirmed a match between the contaminants in the samples and the emissions from the factory. After some initial reluctance, the company temporarily relocated part of the processing of the paint to another site while the plant machinery was altered to eliminate the emissions. The problem was solved in about one and a half years.[4] If the problem had been pursued as a health issue, it would likely still be unresolved today.

It might be objected that the aesthetic argument is fairly frivolous in comparison with the health argument. The aesthetic argument, however, when rephrased as "enjoyment of property" does attain some political stature. When Thomas Jefferson wrote in the Declaration of Independence of American rights to "life, liberty, and the pursuit of happiness," by "pursuit of happiness," he meant the enjoyment of property. Rich and influential people have always, in effect, had a "right" to an aesthetically pleasant environment. When others don't, it becomes an environmental justice problem.

Developing a Preventive Strategy

Taking the approach the City of Garland developed requires advance planning. Otherwise, all kinds of pollution problems will be grandfathered in and made untouchable.

Nevertheless, a community can be effective in dealing with future problems, frequently without any changes in local ordinances. To be effective, however, some person or group of persons must be constantly vigilant. Usually, companies with environmental problems wishing to move into a community must get approval from the local government and must announce their plans in the local paper. Sadly, these announcements normally go

unnoticed and the local community becomes aware of the projects only after it is too late to stop them. The community would be better served if developers were required to more effectively publicize such announcements.

Under no circumstances should citizens agree to reduce environmental standards for a period of time in order to entice an environmentally polluting business into its community. The company will most likely threaten to relocate unless the exemptions are extended or made permanent and relocate if its demands are not met. Such exemptions increase the profits of a company by transforming part of the cost of the product into a social cost to be borne by the community, rather than the company, as an externality. The externalities manifest themselves as health problems and reductions in environmental quality.

People who object to the building of environmentally dangerous facilities in their communities are often called NIMBYs, an acronym that means "not in my backyard." NIMBYs are often accused of refusing to help bear the burden of pollution while accepting the benefits. In response, Eben Fodor, a city planner, has written: "The more people join together to preserve the quality of their 'backyards,' the better off the world will be."[5] If everyone decides that they do not wish a hazardous facility in their community, things will have to be done better.

1. Douglas J. Crawford-Brown and Neil E. Pearce, "Sufficient Proof in the Scientific Justification of Environmental Actions," *Environmental Ethics* 11 (1989): 158.

2. Article I, Environmental Code Enforcement, City of Garland, Division 1, Property Maintenance, Sec. 32.50, Definitions (c).

3. Section 32.51, City of Garland Code of Ordinances.

4. Personal communication, Richard Briley, City of Garland Health Department.

5. Eben Fodor, *Better, Not Bigger: How to Take Control of Urban Growth and Improve Your Community* (Gabriola Island, BC: New Society Publishers, 1999), 49–50.

Toxicological Myths

Dr. Marvin Legator

In the never-ending battle to clean up our environment and make our world safer for humanity, individuals and organizations that profit from polluting the environment have developed a series of scenarios to obfuscate the human effects of exposure to toxic substances. The underlying assumption of toxic waste facilities, and frequently state and federal agencies, is that they know more about the technical aspects of toxicology than the victims of chemical exposure. This arrogance is often manifested in the unnecessary use of technical jargon and misleading or confusing factual information. Informed residents who are knowledgeable as to the adverse health effects of chemical exposure have repeatedly challenged the toxic waste facilities and frequently persevered in obtaining necessary remedial action. The informed citizens of Winona, Texas, are outstanding examples of how to fight for environmental justice and challenge the questionable assertions of the toxic waste facility as well as state and federal agencies. In 1997, MOSES (Mothers Organized to Stop Environmental Sins), under the leadership of one of our present-day environmental heroines, Phyllis Glazer, was instrumental in shutting down the major polluting facility in the community of Winona.

It is my hope that the following list of what I term "Toxicological Myths" will help informed citizens in challenging a toxic waste facility, and thereby arrive at the true facts concerning the adverse health effects of industrial chemicals.

1. The absence of data is the same as negative data.

This is one of the most frequently used statements by those who wish to pollute the environment. Equating the absence of studies to characterize the hazard of a chemical, to running definitive experiments that indeed show the lack of presence of toxicity for a given agent, is a widely used approach to deliberately mislead victims of chemical injury. How often have we heard the statement, "There is no evidence that chemical X causes cancer, birth defects, etc.?" The truth of the matter is that in many instances there have been no studies undertaken

Dr. Marvin Legator was in the Department of Preventive Medicine
and Community Health, Division of Environmental Toxicology
The University of Texas Medical Branch at Galveston

to exonerate the chemical of toxic effects. This is a classic case of the failure of the regulatory governmental agencies to carry out the proper studies, and then use this as an argument to indicate the chemical is free of harm. As long as we consider negative data to be the same as absence of data, there will be little incentive to fill in the huge information gaps that now exist. The literature contains numerous examples where chemicals that were assumed to be safe were later found to be toxic when the proper studies were performed.[1] Always challenge the assertion that chemical X is not toxic, by asking for the references that indicate the chemical is indeed non-toxic.

2. Most industrial chemicals have been tested for hazardous effects.

This myth is a direct consequence of the first myth. The National Research Council has concluded that more than 70 percent of industrial chemicals have not been evaluated for definitive toxic effects.[2] This means that we are exposed to numerous man-made substances where the health effects are unknown. Again, there is little incentive to fill in the gaps when the non-tested chemicals are assumed to be safe from adverse health effects.

3. Animal studies are not relevant for determining human toxicity.

I have always marveled at the fact that none of us would think of using drugs that had not been first tested in animals, but believe that there is a lack of concordance between human and animal studies in the area of industrial toxicology. Actually, animal studies have shown to correlate extremely well with human experience. In the area of chemical carcinogesis, all known human carcinogens were detected or could have been detected in properly conducted animal studies. With many carcinogens, where high level animal studies were used (with extrapolation to human exposure), it has been shown that animal studies actually underestimate the true effects of the carcinogen.[3]

4. A specific chemical produces a specific cancer.

For many years we were of the opinion that a chemical such as vinyl chloride produces a specific cancer such as angiosarcoma of the liver. We know that with the exception of a few chemicals (asbestos) the great majority of chemical carcinogens have multi-organ effects. Vinyl chloride, for instance, produces lung and brain cancers in addition to the liver tumor; benzene produces digestive cancers as well as the various cancers of the hematopoietic system. In addition to chemicals causing cancer, these same chemical carcinogens also produce a wide spectrum of health hazards including neurotoxicity. Agents that cause birth defects

may cause numerous types of these defects as well as other toxicological effects. The specific birth defect of thalidomide (phocomlia) may be the exception rather than the rule.

5. We all respond similarly to chemical exposure.

Each of us is unique and can respond in different manner to the effects of chemicals. I always like to cite the "George Burns Effect," when I discuss our differences in response to chemical exposure. George Burns's life style including smoking multiple cigars daily should certainly lead to an early onset of cancer as well as other possible adverse health effects. Yet this remarkable individual lived to be almost a hundred years old. I believe in the case of George Burns, probably due to genetic inheritance, he was able to repeatedly metabolize carcinogenic substances into non-carcinogens. He was highly fortunate and exceptional to have unique metabolic capabilities. Often the different individual response to chemicals can range over several orders of magnitude. As a general rule we know that children, elderly, and sick are much more sensitive to chemicals than healthy adults, but there are huge differences in chemical response even among healthy adults. Heredity and lifestyle play a major role in determining the outcome from our response to environmental agents.

6. Workplace standards for industrial chemicals can determine a safe dose of exposure to chemicals and can be used in determining safety for communities exposed to industrial standards.

I have mentioned individual variability and our lack of knowledge as to the health effects of many industrial chemicals. How is it possible to determine a safe dose for individuals exposed to chemicals? The answer is that the uncertainties are so great that most quantitative risk assessments are of questionable merit. I often facetiously have said, "God created risk assessors to make astrologers look good." Consider the number of chemicals including benzene, vinyl chloride, and butadiene that were deemed safe to workers at specific levels, where further studies indeed determined the possible safe level to be at least one hundred-fold less than was first estimated. In the case of butadiene, used to manufacture synthetic rubber, the safe level determined a few years ago was 1,000 ppm (parts per million). After additional studies, the regulatory level is currently two ppm. There is no known safe level for cancer-causing compounds; although, we cannot eliminate all carcinogens from our environment. Subsets of our population may be extremely sensitive to adverse health effects of chemicals, and in that case industrial standards should form the threshold for community exposure according to that standard.[4]

Conclusion

All of the above-cited myths, and many that I have not listed, were used in some form to confuse, delay, and discourage those victims of chemical exposure from seeking or obtaining relief. It took years of work of concerned community groups such as MOSES, and tireless work and sacrifice by the leaders of the community such as Phyllis Glazer, to finally reach closure in this matter. This same scenario has repeated itself many times in community after community. I hope the experience of communities such as Winona will inspire the intelligent and informed citizens to persevere until justice is reached.

Dr. Marvin Legator

1. M.S. Legator, C.R. Singleton, D.L. Morris, and D.L. Philips, "Health Effects from Chronic Low-Level Exposure to Hydrogen Sulfide," *Environmental Health* 56 (2001): 123.

2. D. Roe, W. Pease, K. Florini, and E. Sigbergeld, "Toxic Ignorance: The Continuing Absence of Basic Health Testing for Top-Selling Chemicals in the United States," Environmental Defense Fund http://www.environmentaldefense.org/documents/243_toxicignorance.pdf

3. M.S. Legator, "Understanding risk for three important human carcinogens: vinyl chloride, benzene, and butadiene," *Annals of the New York Academy of Sciences* 837 (1997): 170.

4. M.A. McConnell, L.M. Hallberg, and M.S. Legator, "Evaluation of the Use of Effects Screening Levels to Ensure Public Health: A Case Study in Texas," *Journal of Clean Technology, Environmental Toxicology & Occupational Medicine* 6 (1997): 23.